Thomas Eggerer
Gesture and Territory

Rodeo, 2012
Acrylic on canvas
90 × 79 inches
228.6 × 200.7 cm

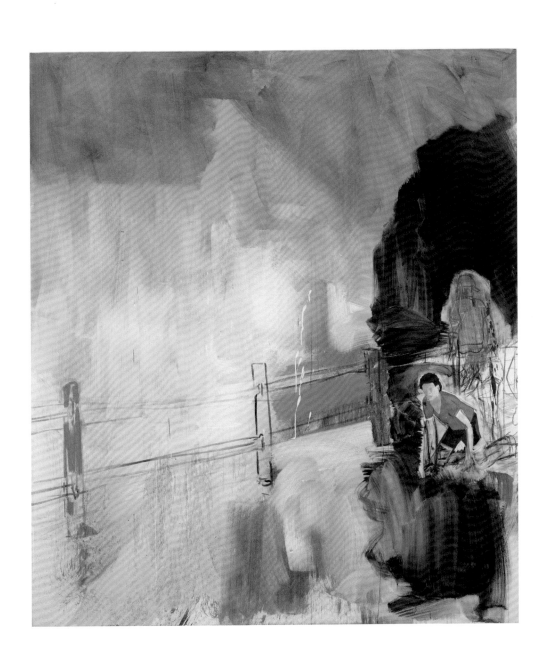

Waste Management, 2012
Acrylic and oil on canvas
82 × 82 inches
208.3 × 208.3 cm

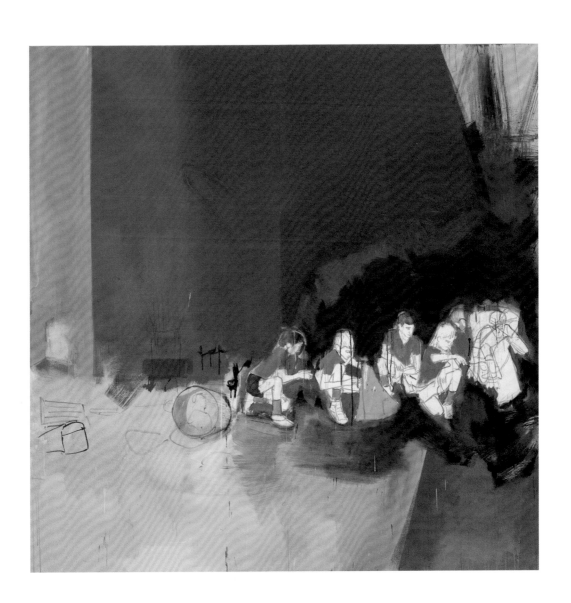

Recycler, 2013
Acrylic and pastel on canvas
107 × 90 inches
271.8 × 228.6 cm

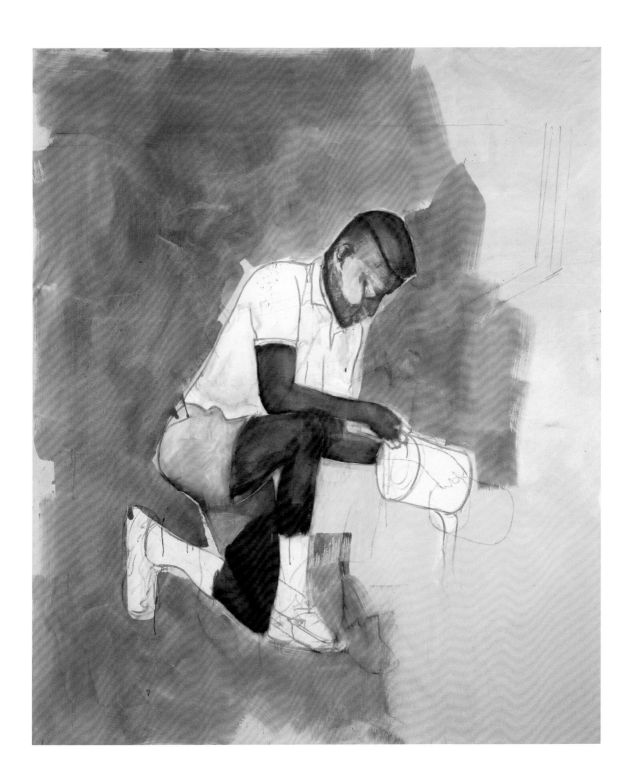

Carousel, 2013
Acrylic on canvas
85 × 85 inches
215.9 × 215.9 cm

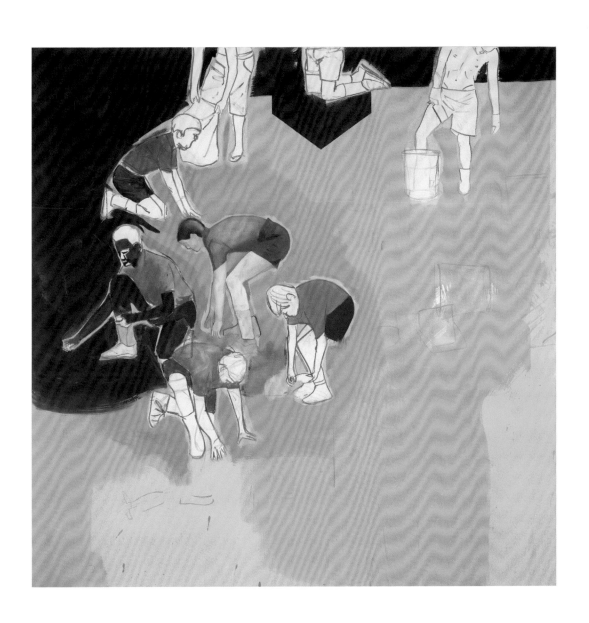

Giro, 2013
Acrylic and oil on canvas
82 × 82 inches
208.3 × 208.3 cm

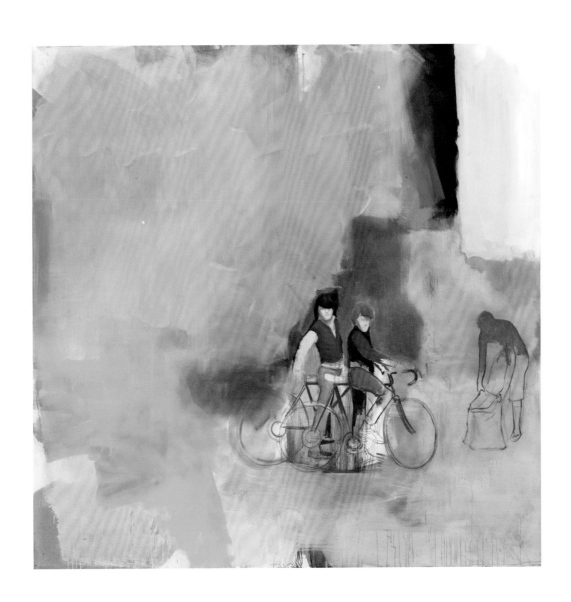

The Ruins, 2013
Acrylic and oil on canvas
73 × 67 inches
185.4 × 170.2 cm

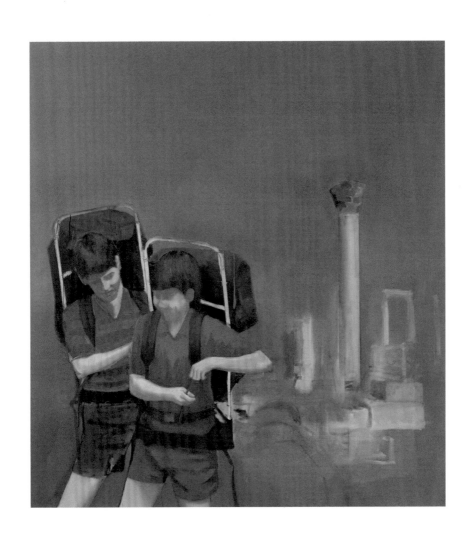

Triple Constellation, 2013
Acrylic on canvas
86 × 83 inches
218.4 × 210.8 cm

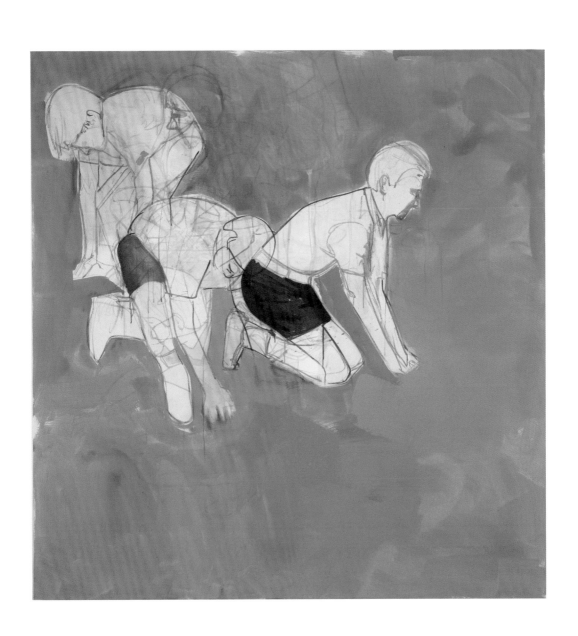

Grey Harvest, 2013
Acrylic and oil on canvas
107 × 90 inches
271.8 × 228.6 cm

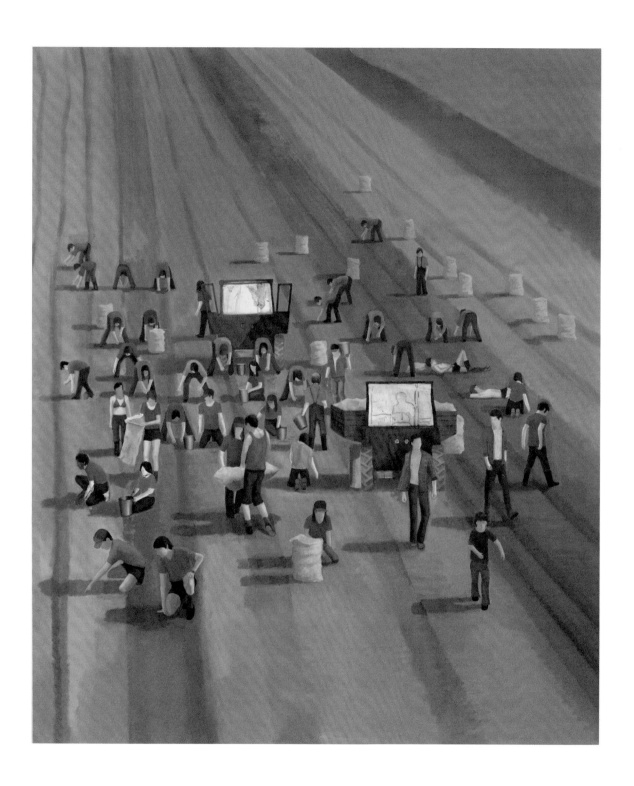

Floorpiece, 2013
Acrylic, oil, and charcoal
on canvas
51 × 46 inches
129.5 × 116.8 cm

The Connoisseur, 2012
Acrylic on canvas
86 × 83 inches
218.4 × 210.8 cm

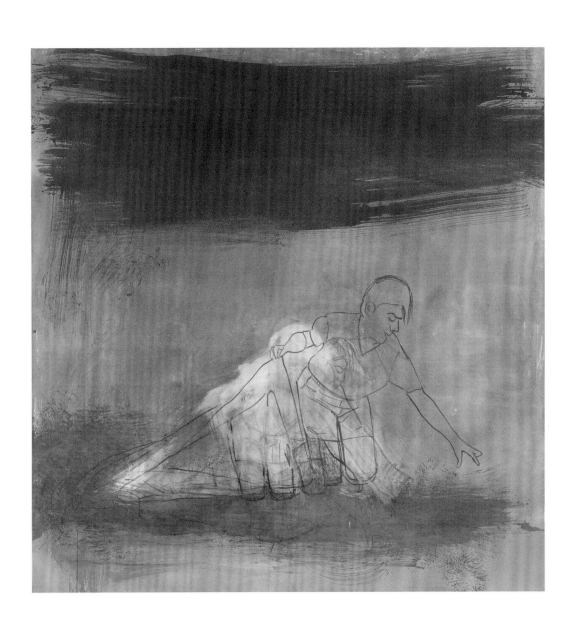

Campagna, 2012
Acrylic on canvas
90 × 79 inches
228.6 × 200.7 cm

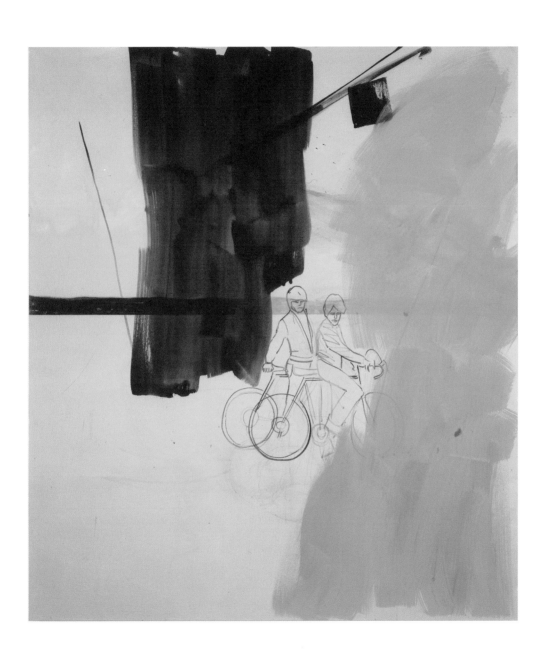

Untitled, 2013
Acrylic on canvas
107 × 90 inches
271.8 × 228.6 cm

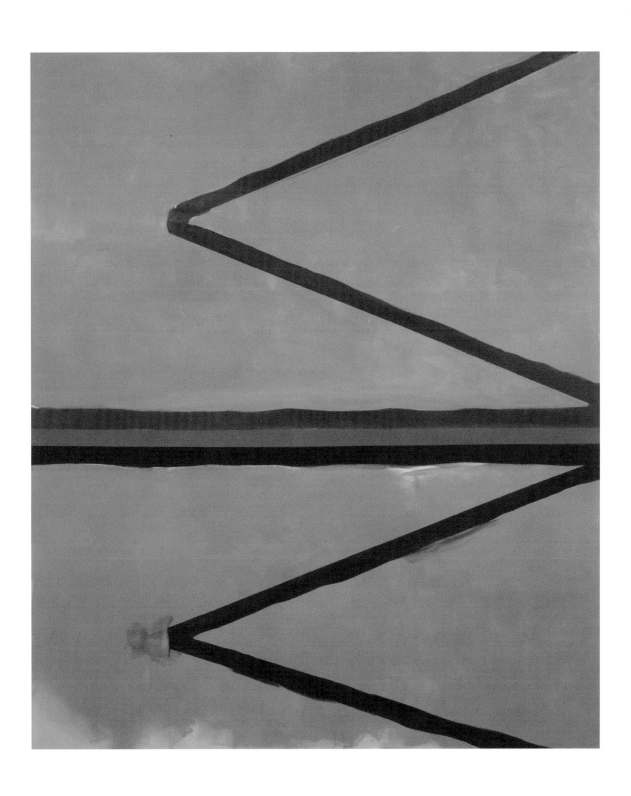

Untitled, 2013
Acrylic, pencil, and carbon
on paper
107 ¼ × 89 ¾ inches
272.4 × 228 cm

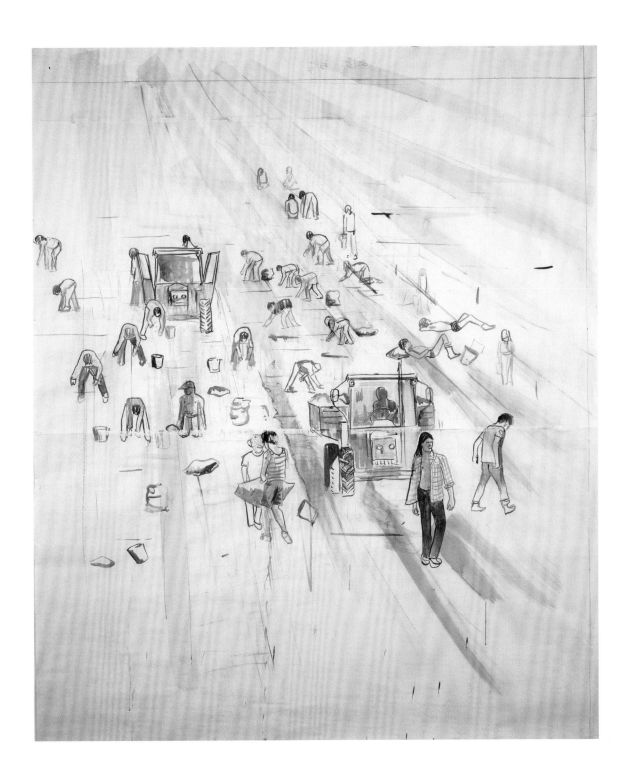

Untitled, 2013
Acrylic, pencil, and carbon
on paper
106 ½ × 90 ⅛ inches
270.5 × 228.9 cm

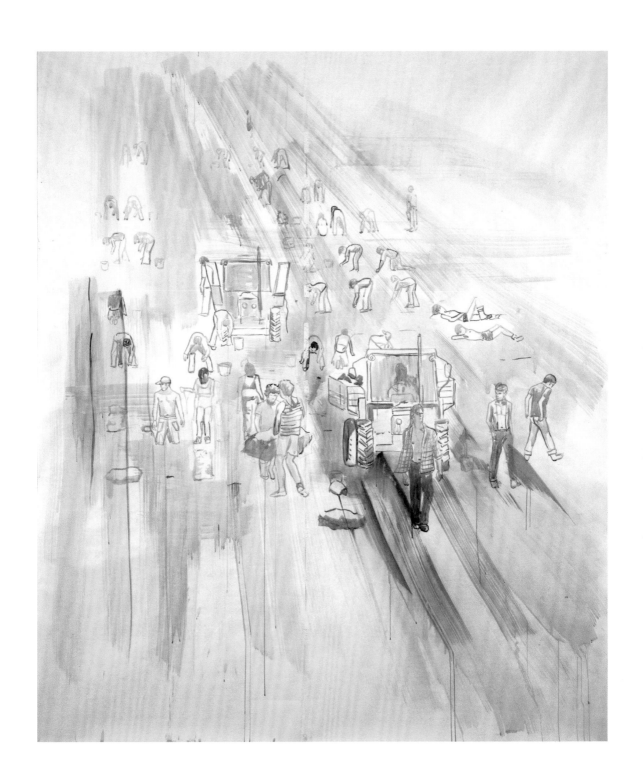

Untitled, 2013
Acrylic, pencil, and carbon
on paper
82 × 82 inches
208.3 × 208.3 cm

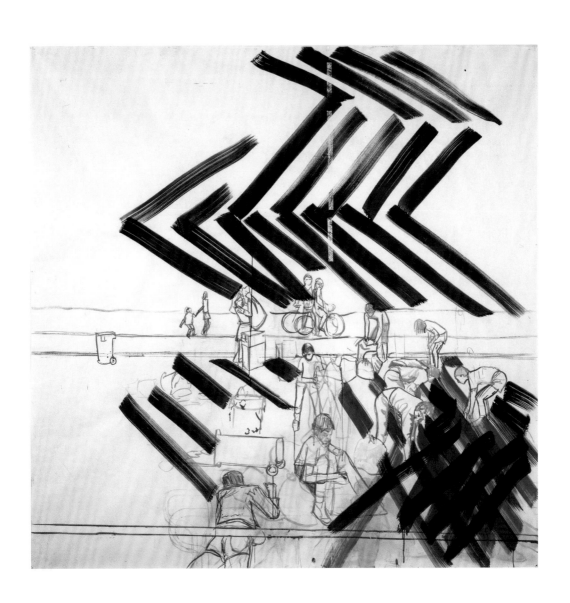

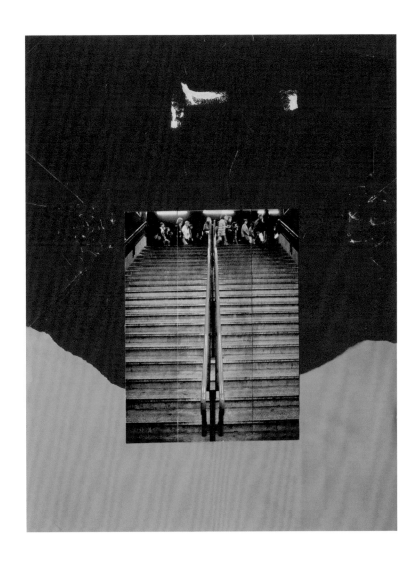

Untitled, 2013
Collage
23 ½ × 17 ¾ inches
59.4 × 45.1 cm

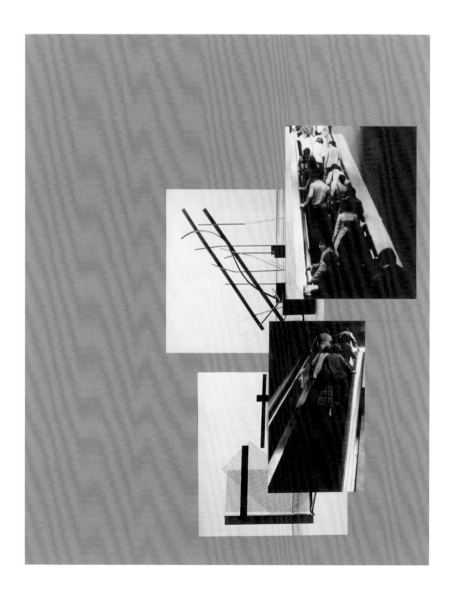

Untitled, 2013
Collage
25 × 19 ¾ inches
63.5 × 50.2 cm

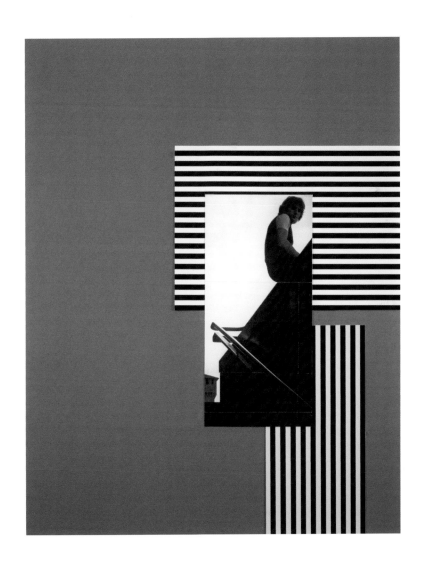

Untitled, 2013
Collage
23½ × 18 inches
59.4 × 45.8 cm

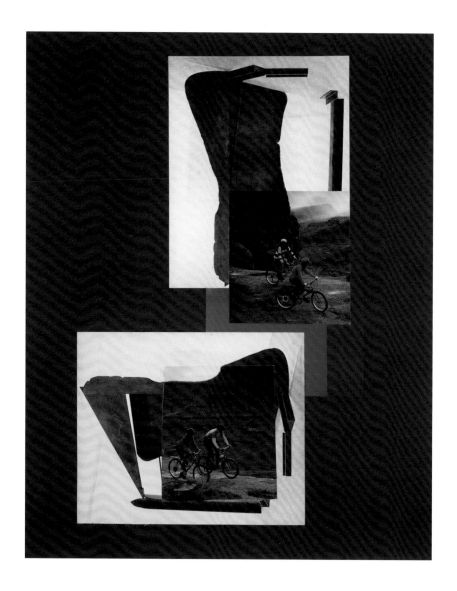

Untitled, 2013
Collage
24 ¾ × 19 ⅞ inches
62.9 × 50.4 cm

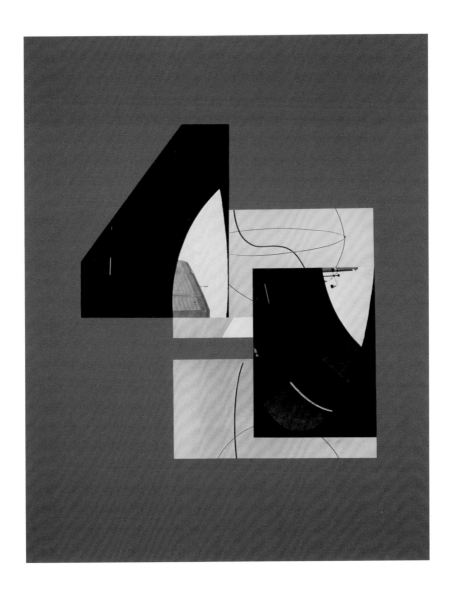

Untitled, 2013
Collage
24 7/8 × 19 3/4 inches
63.1 × 50.2 cm

"Everyone has a job"
Devin Fore

1 Interview with Thomas Eggerer, May 18, 2013.

2 The *Oxford English Dictionary* proposes an etymological connection between *job* and *gob*, meaning "mass or lump." See "† job, n.3" and "gob, n.1," *OED* online, June 2013, http://www.oed.com/view/Entry/101395 and http://www.oed.com/view/Entry/79579.

3 Theodor W. Adorno, "Free Time," in *Critical Models: Interventions and Catchwords*, trans. Henry W. Pickford (New York: Columbia University Press, 1998), 170. According to Adorno, the camper's fantasy of "sleeping under the open sky" is designed merely to "compel people to buy tents and trailers, along with innumerable accessories." Similarly, he observes about sunbathing that "those who let themselves roast brown in the sun merely for the sake of a tan ... become fetishes to themselves."

It isn't clear what exactly the people in Thomas Eggerer's latest work are doing. When asked in an interview for clarification, the artist replied simply: "Everyone has a job."[1] The reference in Eggerer's response to the soft-focus notion of *job* is exceedingly apt. For unlike the high-contrast concept of *labor*, an analytic category indispensable to rigorous political economy, the very indistinctness and plasticity of the word *job*, which is etymologically related to the noun *gob*,[2] reflects the historical erosion of the boundary between productive employment and free time. The story is a familiar one: in the second half of the previous century, the activities of work and recreation began to intertwine and exchange properties, eventually arriving at a point today where the spontaneous practices of self-fashioning known as "lifestyle" have become effectively indistinguishable from the work skills being cultivated in the service industry. Now there is no longer any meaningful contrast between labor and leisure, just a series of jobs to be done.

Eggerer's massive painting *Grey Harvest* (p. 19), the linchpin of his recent work, takes its cues from depictions of the collective farm, a *locus classicus* of Socialist Realism, although in Eggerer's version the farm teems with figures whose purpose has little to do with labor that is recognizably productive or valorized: some of the people pause in repose; many drift and wander; others observe the enterprise unhurriedly; still others reconnoiter the landscape in a state of distraction. If it is an episode of work that we have before us, the figures are certainly far too casual, relaxed, and absentminded; but if, conversely, we are looking at a scene of recreation, the atmosphere is far too glacial, hoary, and lifeless. Like the woman scanning the ground in a bikini top and the child running into the foreground, the misplaced hipster with long hair and a trucker's cap is better suited for the informal beach scene of *Sand* (2007) than for the collective labor enterprise of the harvest. But the point is that these figures are indeed at work. Despite the appearance of freedom and spontaneity, the practiced choreography of prefabricated diversions such as camping and sunbathing— two "pseudo-activities," Adorno once called them[3]—in fact mimics structural conditions of objective unfreedom and coercion. At a time when even the most anticonformist improvisations of self-expression can be readily monetized, the individual becomes the simultaneous subject-object of exploitation, an entrepreneur of himself. The result in Eggerer's work is an anomic sublation of the respective utopias of Socialist Realism and Pop Art, a convergence between the fantasy of limitless production and that of perpetual consumption.

Grey Harvest presents a comprehensive breviary of the gestures, attitudes, and postures that recur across the recent paintings. Despite their obscurity of purpose and appearance of hermetic solipsism, the solitary movements that each of the figures carries out are neither personal nor idiosyncratic. Their withdrawal and interiority are not

signs of individuality. To the contrary, this fixed gestural repertoire, drawn from a standardized lexicon of movement that cuts across the figures and connects them to one another, denies the individual's semblance of autonomy and instead gives the entire social ensemble a rigorously schematic and anonymous quality. Their activities appear meaningless. It is not surprising, then, that so many of Eggerer's paintings depict adolescents, creatures on the developmental threshold between the anarchic sexuality of childhood and the regulated-drive economy of the adult: theirs are bodies on the cusp of cultural territorialization, bodies in which the awkward gap between social code and physical performance still remains all too glaring. In *The Ruins* (p. 15), for example, Eggerer contrasts the maladroit functioning of the adolescent hands with the rigid frame-packs worn by the boys. At this stage of human development, the mapping of social comportment onto the body is still a shoddy and makeshift affair, obvious in its utter arbitrariness. By focusing on this interval of non-correspondence between body and code, Eggerer exposes the lack of content, indeed inexpressiveness, of gesture, so long considered the signature of individuality, especially in painting: "You can have children do things in paintings that you couldn't get away with an adult doing," he notes. "I had one child sticking out an arm in a weird pose—*if a child does that, it doesn't mean anything, if an adult does that, it will be surreal or narrative.*"[4] Although the people in Eggerer's paintings concentrate intensely on their respective jobs and seem to be immersed in a space of psychological interiority, they execute their movements compulsively and with a mechanicity that recalls the empty formalism of phatic consumer ritual far more than the Taylorized efficiency of industrial production.

It's hard to imagine, then, that these empty reflexes are aimed at producing any results. They do not envision a possible future, but are instead oriented retentionally, in the phenomenological sense: they are memories or vestiges of past activities. Indeed, the scenes depicted in paintings such as *Grey Harvest*, *The Connoisseur* (p. 23) and *Carousel* (p. 11) are suffused with belatedness and retrospection: these people are not agents of history or heroes of labor, but the maintenance crew that has arrived to clean up after the main event. This pervasive sense of belatedness finds an apt iconographic vehicle in one particularly anachronistic gesture that is repeated across a number of Eggerer's paintings: gleaning. Depicted most famously in Jean-François Millet's *Des glaneuses* (1857), the activity of gleaning— its gesture of crouching and collecting—is a practice that belongs to a premodern time rendered obsolete with the advent of industrial production. However, despite its defunctionalization, the gesture still persists, transformed in its afterlife into an empty muscular reflex, an echo that continues to resound in the body. "Gleaning may be extinct," Agnès Varda explains in a film essay on Millet's painting,

4 Morgan Falconer, "New York: Thomas Eggerer," *Art World* (December 2008): 72. Italics added.

5 *The Gleaners and I*, dir. Agnès Varda (2000).

"but stooping has not vanished."[5] Having outlived its original social motivation, the once-purposive activity of gleaning is demoted to the conditioned reflex of stooping, a movement without content, no longer guided by, or even bound to, the intentions of the conscious subject. Transmitted across generations, such obstinate gestures take on a life of their own, Brecht once observed: "I often see, says the thinking man, that I have the stance of my father. But my deeds aren't those of my father. Why are my deeds different? Because what is necessary is different. But I see that the stance endures longer than the form of action: it resists what is necessary."[6]

6 Bertolt Brecht, *Werke. Große kommentierte Berliner und Frankfurter Ausgabe*, 30 vols. (Frankfurt: Suhrkamp Verlag, 1988–98), 28:34.

The figures in Eggerer's painting inhabit a state beyond readiness and laxity, beyond vigor and enervation: they hunch and kneel, folding limbs one over the other; they bend and contract, slouching to reveal a particular curve of the back. Not quite upright, but also not exactly supine, they instead inhabit a culturally unmarked zone between vertical and horizontal. This suppression of the valorized and familiar axes of the human frame allows more creaturely, less recognizable aspects of the body to emerge. Like the figures in Valie Export's photographic series *Body Configurations in Architecture* from the 1970s, the flexible and metamorphotic people in Eggerer's paintings readily accommodate their environment, receding into the surrounding space. For Export and Eggerer alike, the mitigation of the overtly anthropomorphic qualities of the body and its assimilation into the space around it suggest a technique of camouflage and survival. Many of the figures crouch and turn away to evade the eyes of the spectator; the refraction of the body in works like *Triple Constellation* (p. 17), which recalls multiple-exposure chronophotography, confuses the viewer, who doesn't know which of the figures to focus on; some of the figures, mere outlines, are on the cusp of vanishing entirely.

These evasions—strategies to set the viewer's eyes in motion—establish a third painterly space beyond figuration and abstraction. Here Eggerer's technique proceeds in two phases: first, by slackening the human frame, by diminishing its heroic and narrative qualities, Eggerer compels the spectator's eye to slide off the body, to the side, where it alights on a space that, in the words of philosopher Paul Virilio, is neither figure nor ground, but "a third, formed by their conjunction, the void, the transparence [that takes] shape between them, the interform"; then, to capture and give material density to the fugitive "interform," Eggerer thickens this local field through the superaddition of more paint, often applied coarsely and spontaneously. This secondary inspissation, added after the basic values of figure and ground have already been articulated on the canvas, can be seen in almost all of Eggerer's new work, whether in the vertical mantle of black in *Rodeo* (p. 5), the blue miasma that emerges at the right of *Waste Management* (p. 7), or the dark swathe that contours the group of figures in *Carousel*. The function previously performed

by an architectural cage in works like *Atrium* (2003), *The Wisdom of Concrete* (2004), or *Trinity* (2005) is now taken over by this thickened, pressurized atmosphere. Eggerer contours what Virilio calls the "isthmus" or "peninsula of emptiness" between the figures, giving the negative space of the canvas a palpable presence, which, while not being figural per se, can no longer properly be called background either. Instead it represents a tertiary painterly space that, paradoxically, utilizes the figures themselves as its ground. The result inverts the traditional model of space, understood in the Cartesian analytic as an empty, homogenous, and stable container of infinite extension that preexists the figures, objects, and events contained within it. In Eggerer's paintings, it is not a static space that occasions the moving figure, but the figures that occasion a space that is "nothing more than a series of edges." More than just destabilizing the "abusive hierarchy of form over ground," this strategy, to quote Virilio again, interrogates the longstanding exclusivity between "the figurative and the abstract."[7]

7 Paul Virilio, *Negative Horizon: An Essay in Dromoscopy*, trans. Michael Degener (New York: Continuum, 2005), 32, 33, 30, 33, 28.

Eggerer's project to reallocate the values of figure and ground fuels a second current within his work as well, the series of abstract paintings based on details of alphabetic lettering. The visual convention used here, that of typography, also troubles the traditional hierarchy of container and content, but now with different means. For the relationship in printing between the letter and the paper beneath it, while superficially homologous to the relationship in painting between figure and ground, in fact shares nothing with the latter: rather than projecting an illusion of perspectival space, letter and paper, inscription and support, are differential and co-constitutive. The page does not contain or antecede the words on it in the same way that a picture frame is conventionally said to "contain" that which it depicts. Rather, the white of the page is occasioned by the black of the printed letter in the same way that sound or noise, in a Cagean account, can be said to produce the surrounding condition of silence. And although the paradigm of letter print, with its differential logic, is referenced most explicitly in Eggerer's abstract paintings based on typography, it also surfaces in mimetic works such as *Grey Harvest*, where the formalized postures of the gleaners recall a hieroglyphic code. Here the landscape, striated by receding orthogonals, is invaded by graphemic elements that transform the painting from a depth image to be perceived into a flat frieze to be read. This metamorphosis of the landscape into a data field is consummated by the arrival of two tractors whose windows puncture the scene like two luminous computer screens, perforating the plenitude and presence of embodied vision with the sign of absence, a transmission from elsewhere.

Devin Fore is Associate Professor at Princeton University, author of *Realism after Modernism* (Cambridge, Mass.: MIT Press, 2012) and editor of the journal *October*.

THOMAS EGGERER

Born 1963 in Munich, Germany

Lives and works in New York, New York

SOLO EXHIBITIONS

2013
Gesture and Territory, Petzel Gallery, New York, New York

2012
The Sound and the Scent, Maureen Paley Gallery, London, UK

2011
In der Pyramide, Galerie Daniel Buchholz, Cologne, Germany

2010
The Rules of the Fence, Friedrich Petzel East, New York, New York

Fence Romance, Galerie Daniel Buchholz, Berlin, Germany

2008
The Goodbye Look, Richard Telles Fine Art, Los Angeles, California

Navigator: Thomas Eggerer in conversation with Jacob van Ruisdael and Pieter Saenredam, Frans Hals Museum, Haarlem, The Netherlands

2007
Run River, Friedrich Petzel Gallery, New York, New York

2006
Thomas Eggerer. O Pioneers, Galerie Daniel Buchholz, Cologne, Germany

2004
Friedrich Petzel Gallery, New York, New York

2003
Richard Telles Fine Art, Los Angeles, California

Thomas Eggerer. Atrium, Kunstverein Braunschweig, Braunschweig, Germany

2002
Matrix 148, Wadsworth Atheneum Museum of Art, Hartford, Connecticut

Galerie Daniel Buchholz, Cologne, Germany

2001
Richard Telles Fine Art, Los Angeles, California

1999
Galerie Daniel Buchholz, Cologne, Germany

SELECTED GROUP EXHIBITIONS

2013
Tell It To My Heart: Collected by Julie Ault, Museum für Gegenwartskunst, Basel, Switzerland; Kulturgest, Lisbon, Portugal

2012
Preludes, Thomas Eggerer and R. H. Quaytman, Friedrich Petzel East, New York, New York

Variationen über ein Thema, Hochschule für Grafik und Buchkunst, Leipzig, Germany

2011
Looking Back / The 6th White Columns Annual, White Columns, New York, New York

Quodlibet III, Alphabets and Instruments, Galerie Buchholz, Berlin, Germany

2009
Compass in Hand: Selections from The Judith Rothschild Foundation Contemporary Drawing Collection, The Museum of Modern Art, New York, New York

Quodlibet II, Galerie Buchholz, Cologne, Germany

2008
Idle Youth, Gladstone Gallery, New York, New York

The Painting of Modern Life, Castello di Rivoli, Turin, Italy

Form und Grund: Eggerer, Baer, von Wulffen, Belvedere/Augarten Contemporary, Vienna, Austria

Passageworks: Contemporary Art from the Permanent Collection, San Francisco Museum of Modern Art, San Francisco, California

2007
Fit to Print, Gagosian Gallery, New York, New York

Detourism, Orchard Gallery, New York, New York

The Painting of Modern Life, Hayward Gallery, London, UK

2005
Galerie Daniel Buchholz, Köln at Metro Pictures, Metro Pictures, New York, New York

Richard Telles Fine Art, Los Angeles, California

Visiting Faculty Show, Harvard University, Cambridge, Massachusetts

2004
Dass die Körper sprechen, auch das wissen wir seit langem, Generali Foundation, Vienna, Austria

The Undiscovered Country, UCLA Hammer Museum, Los Angeles, California

Quodlibet, Galerie Buchholz, Cologne, Germany

2003–04
Baja to Vancouver—The West Coast and Contemporary Art, organized collaboratively by Seattle Art Museum, Seattle, Washington; Museum of Contemporary Art San Diego, San Diego, California; Vancouver Art Gallery, Vancouver, Canada; CCA Wattis Institute for Contemporary Arts, San Francisco, California

2003
deutschemalereizweitausenddrei, Frankfurter Kunstverein, Frankfurt, Germany

2002
Hossa. Arte Alemán del 2000, Centro Cultural Andratx, Mallorca, Spain

Painting on the Move—Nach der Wirklichkeit, Kunsthalle, Basel, Switzerland

snapshot—New Art from Los Angeles, UCLA Hammer Museum, Los Angeles, California; Museum of Contemporary Art, Miami, Florida

Thomas Eggerer, Jochen Klein, Amelie von Wulffen, Galerie Ascan Crone, Hamburg, Germany

2000
Galerie Daniel Buchholz, Cologne, Germany

1999
Malerei, INIT Kunsthalle, Berlin, Germany

1998
Galerie Daniel Buchholz, Cologne, Germany

1996
Three Rivers Arts Festival, with Group Material, Pittsburgh, Pennsylvania

Eggerer/Klein, Printed Matter, New York, New York

1995
Market, with Group Material, Kunstverein München, Munich, Germany

1994
Oh Boy, It's a Girl!—Feminismen in der Kunst, Thomas Eggerer/Jochen Klein, Kunstverein München, Munich, Germany; Kunstraum Vienna, Austria

Die Utopie des Designs, collaborative exhibition project, Kunstverein München, Munich, Germany

SELECTED BIBLIOGRAPHY

2013
Thomas Eggerer, "Meditations of the Split Self," in Helen Molesworth, *Amy Sillman, one lump or two*, exh. cat., Boston: Institute of Contemporary Art/Boston with DelMonico Books/Prestel, 2013, 147–53

2012
Willem de Rooij, "Best of 2012," *Artforum*, December 2012, 245

Martin Coomer, "Thomas Eggerer," *Time Out London*, April 2012, 52

Will Heinrich, "The End of the Beginning," *New York Observer*, January 16, 2012, B6

Thomas Eggerer and R. H. Quaytman, "Preludes," *Timeout*, January 15, 2012

2011
Caroline Busta, *Vitamin P2, New Perspectives in Painting*, London: Phaidon Press Limited, 2011, 96–97, 340

David Joselit, "Signal Processing," *Artforum*, Summer 2011, 356–61

2010
Julie Ault, ed., *Show and Tell: A Chronicle of Group Material*, London: Four Corners Books, 2010, 198–207

Susanne Leeb, "Zustände der Malerei. Über Thomas Eggerer in der Galerie Daniel Buchholz, Berlin," *Texte zur Kunst*, no. 77, March 2010, 219–24

Helmut Draxler, "Malerie als Dispositiv," *Texte zur Kunst*, no. 77, March 2010, 38–46

Hans-Jürgen Hafner, "Baukästen des Begehrens," *artnet*, February 13, 2010

"Thomas Eggerer: 5 February–27 March," *Frieze*, no. 128, January/February 2010, 33

2009
David Joselit, "Painting Beside Itself," *October*, no. 130, Fall 2009

2008
Eva-Maria Stadler, "Form und Grund," in *Form und Grund: Eggerer, Baer, von Wulffen*, exh. cat., Belvedere/Augarten Contemporary, Vienna, 2008, 12–16

Morgan Falconer, "New York: Thomas Eggerer," *Art World*, December 2008/January 2009, 72–77

Thomas Eggerer, "The Artists' Artists: Best of 2008, 'Threads of Splendor' (Metropolitan Museum of Art, New York)," *Artforum*, December 2008, 108

2007
Martin Herbert et al., *The Painting of Modern Life: 1960's to Now*, London: Hayward Publishing, 2007, 157–61

Impulse: Works on Paper from the Logan Collection Vail, exh. cat., Logan Collection, Vail, 2007, 120

Martha Schwendener, "Thomas Eggerer," *New York Times*, Weekend Arts sec., October 19, 2007, E35

2006
Helmut Draxler, "Erfahrungen vor Gruppen. Mediale und soziale Konstellationen bei Thomas Eggerer," in *Thomas Eggerer. O Pioneers*, exh. cat., Galerie Daniel Buchholz, Cologne, 2006, 31–46

2005
Russell Ferguson, "Lost in Space," *Artnews*, January 2005, 70

David Joselit, "Terror and Form," *Artforum*, January 2005, 45ff

2004
Russell Ferguson, "The Undiscovered Country," in *The Undiscovered Country*, exh. cat., Hammer Museum, University of California, Los Angeles, 2004, 104–09

"Everybody Was There: The Wrong Guide to New York in 2004," *Artforum*, December 2004, 183

P. C. Smith, "Thomas Eggerer at Friedrich Petzel," *Art in America*, November 2004, 117

2003
Diedrich Diederichsen, "Königsdramen und Klassenreisen," in *Thomas Eggerer. Atrium*, exh. cat., Berlin: Lukas & Sternberg, 2003, 11–16 (German), 43–47 (English)

Matthew Higgs, "Thomas Eggerer," in *Baja to Vancouver—The West Coast and Contemporary Art*, exh. cat., CCA Wattis Institute for Contemporary Arts; Museum of Contemporary Art San Diego; Seattle Art Museum; Vancouver Art Gallery, 2003, 50ff

David Joselit, "Thomas Eggerers Antigravitations-Malerei," in *Thomas Eggerer. Atrium*, exh. cat., Berlin: Lukas & Sternberg, 2003, 19–22 (German), 49–51 (English)

Christine Mehring, "Mensch und Masse," *Texte zur Kunst*, no. 49, March 2003, 176–79

2002
Nicholas Baume, *Matrix 148: Anxious Pleasures*, exh. brochure, Wadsworth Atheneum Museum of Art, Hartford, 2002

2001
David Joselit, "Openings: Thomas Eggerer," *Artforum*, October 2001, 148–49

Ali Subotnick, "Snapshot: New Art from Los Angeles," *Frieze*, no. 62, October 2001, 99–100

1999
Frank Frangenberg, "Thomas Eggerer—Galerie Daniel Buchholz," *Kunstforum*, no. 147, September 1999

Astrid Wege, "Erkundungen im Ungewissen," *Texte zur Kunst*, no. 35, September 1999, 321–25

Thomas Eggerer, "Schnee in Beverly Hills," *Texte zur Kunst*, no. 33, March 1999, 163–67

1998
Thomas Eggerer, "Was macht eigentlich ... Donald Baechler?," *Texte zur Kunst*, no. 32, December 1998, 108–12

——, "Was macht eigentlich ... Julian Schnabel?," *Texte zur Kunst*, no. 31, September 1998, 154–58

——, "Rollenspiele in Kulissen, Heimo Zobernig im Bonner Kunstverein," *Texte zur Kunst*, no. 30, June 1998, 140–43

——, "Spurensuche im Bonsaiwald. Einige Aspekte in den neueren Arbeiten von Cosima von Bonin," *Texte zur Kunst*, no. 29, March 1998, 68–76

1996
Thomas Eggerer and Jochen Klein, "Virtually Queer—Gay Politics in der Clinton Ära," *Texte zur Kunst*, no. 22, May 1996, 140–47

——, "Communication as ritual—die Talkshow im amerikanischen TV," *Texte zur Kunst*, no. 21, March 1996, 40–45

1995
Group Material (Doug Ashford, Julie Ault, Thomas Eggerer, Jochen Klein), "It's time for a change ... let your true voice be heard," *Market*, exh. cat., Kunstverein München, Munich, 1995

1994
Thomas Eggerer and Jochen Klein, *Die Funktion der Kunst im Gesamtkomplex der Olympischen Spiele in München 1972. Die Utopie des Designs*, exh. cat., Kunstverein München, Munich, 1994

——, *Oh Boy, It's a Girl!—Feminismen in der Kunst*, exh. cat., Kunstverein München, Munich, 1994, 72–73

——, "Der Englische Garten in München," unpublished

This catalogue is published on the
occasion of the exhibition

Gesture and Territory
Petzel Gallery, New York
October 10 – November 9, 2013

Text author
Devin Fore

Editor
Lucy Flint

Designer
Neil Donnelly

Photographers
Larry Lamay and Jason Mandella

Project manager
Ko Sadakuni

The artist would like to thank Devin
Fore, Neil Donnelly, Lucy Flint, Larry
Lamay, Amy Sillman, Sergej Jensen,
Mathias Poledna, Stephen Prina,
Dustin Hodges, Ko Sadakuni, Andrea
Teschke, and Friedrich Petzel.

ISBN 978 0 615 88078 5